This book is for
Kate again.
And again and
again and again.

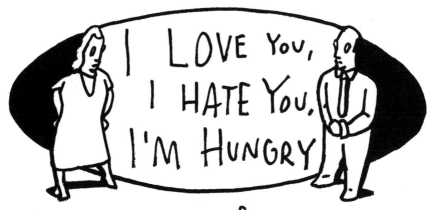

I LOVE You, I HATE You, I'M HUNGRY

a collection of cartoons

BRUCE ERIC KAPLAN

SIMON & SCHUSTER

New York London Toronto Sydney

Simon & Schuster
1230 Avenue of the Americas
New York, NY 10020

First Simon & Schuster hardcover edition January 2010

SIMON & SCHUSTER and colophon are registered trademarks
of Simon & Schuster, Inc.

For information about special discounts for bulk purchases,
please contact Simon & Schuster Special Sales at
1-866-506-1949 or business@simonandschuster.com.

The Simon & Schuster Speakers Bureau can bring authors
to your live event. For more information or to book an event
contact the Simon & Schuster Speakers Bureau at
1-866-248-3049 or visit our website at www.simonspeakers.com.

Manufactured in the United States of America

1 3 5 7 9 10 8 6 2

Library of Congress Cataloging-in-Publication Data

Kaplan, Bruce Eric.
I love you, I hate you, I'm hungry / Bruce Eric Kaplan.
p. cm.
I. Title
PN6727.K274I33 2010
741.5'973—dc22 2009021810

ISBN 978-1-4165-5694-7

INTRODUCTION

I worked at my son's preschool today. It's a co-op so I spend a day there at least once a month. I sort of dread doing it, yet when it happens it's not so bad. The snack comes midway through the morning and that is the highlight for me. Today, there were strange red rice crackers, hot dogs, and sad green grapes. I had been so excited and then I was so disappointed.

Not that much happens during a morning at preschool, yet at the same time, of course, everything happens. Today, someone noticed a stink beetle on the ground and everyone gathered around. A girl drew on someone else's painting. One boy threw a tiny rake that nearly took out a teacher's eye. Early in my first moments there, I witnessed one boy tell another boy that the reason he wasn't invited to a party was that no one likes him. The boy no one likes took it much better than I would have.

Later, after the dreadful snack, some kids were at an arts and crafts table beading pieces of colored wire. These turned out to be necklaces, albeit necklaces that hung funny. One girl was having the time of her life beading her wire. Then, seconds later, she was outside, weeping. She wept until the end of preschool. She was truly inconsolable. I never found out why.

Another boy at the arts and crafts table was insistent that he needed foamy beads. I tried to find some for him, but I couldn't. So I simply walked away, hoping he had forgotten about the foamy beads. He hadn't. Fifteen minutes later, I saw a teacher telling him that they didn't have any foamy beads—in fact, they had never had foamy beads. He calmly insisted that he needed foamy beads. I found that admirable.

Anyway, now here I am, and it is night and it all seems so long ago. What should I say about the cartoons in this collection? In looking back at them I see that the vast majority are about relationships. God, "relationships" is such a terrible word. It makes relationships sound so dreary, not fun at all. "Fun" is a good word. "Relationships"—terrible word.

And most of the relationships in this book are romantic or sexual or unromantic and unsexual but would be romantic and sexual if people were in a better mood. Or if they were not tired because of work. Or because of life.

But also there are cartoons about other kinds of relationships, such as those one has with parents, or friends, or neighbors, or enemies, or food, or whatever.

I think my first real relationship was with my wallpaper. I mean it. I remember reaching through my crib and touching it. It was yellow and reassuringly bumpy. Somehow it soothed me. Even writing about it now, four decades later, makes me feel better, as I have been feeling a little anxious all day—which is actually how I spend every day.

Another early important relationship I had was with a little enclosed space under a shelf in our den. I used to crawl in there and sit with some little objects (I can't remember what they were exactly, so I guess I didn't have that vivid a relationship with them) and say I was working in the Underbakery. The Underbakery was next to the radiator in the room and it was cozy and I remember I would feel very safe and secure when I was in the Underbakery.

The den had an object in the center of it that I had an extremely intense relationship with—the television. I still do. The television was a real lifeline for me. It nourished me. It showed me so much about what life was and could or should be. I laughed, I cried, I was confused, I felt understood when I watched television.

It's strange—it suddenly strikes me that it hasn't occurred to me

VI

to mention my mother, or my father. They were there too during my childhood. I am just not sure what they were doing.

An early romantic relationship for me was with Diane Kolankowski, who I met in elementary school. She had such great hair, which I think is the most important thing about people, but maybe that is just because I am bald. Diane Kolankowski, Diane Kolankowski—I remember her second-grade party as if it were yesterday. That party was something. I remember it so clearly. More than I remember her, which says a lot.

But back to the cartoons. Perhaps the most interesting relationship depicted in them is one's relationship with oneself. No matter where you go, you're always stuck with you, you can't get rid of you, and believe me, I've tried. To get rid of me, not you I mean. (You are fine, I guess.)

All of this talk puts me in mind of a theory I once heard that has always stayed with me. It's that everything we do, we do for one of three reasons: because we love someone, because we hate someone, or because we're hungry. Think about it. It's really true. (Oh, I probably don't need to tell you this, but when I say we're hungry, I don't just mean we want food, although most of the time we do just want food. I mean, we have a need or an emptiness or a sadness. Like that boy at preschool today, we just want the foamy beads. Even if they don't exist and never have.)

In any case, here are the cartoons. I hope they have some meaning for you, whoever you are. If by any chance they do, I know why— you either love someone, you hate someone, or you're hungry. Trust me, it's one of those three things.

Bruce Eric Kaplan
Los Angeles, California

I Love You,
I Hate You,
I'm Hungry

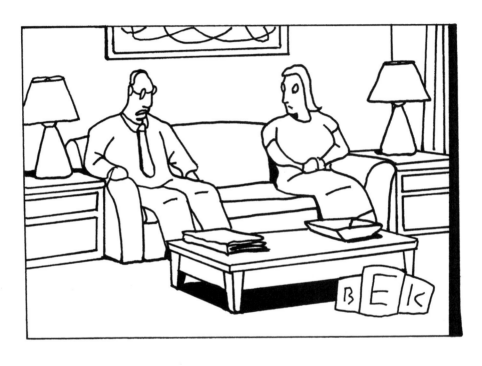

"Should we halfheartedly try to relate?"

"I want someone whose inner pain is totally hot."

"Do you realize that Tarzan and Jane are the only people we ever see?"

*"When the shameless self-promoting starts
to feel like a job, then I'll stop."*

"*Let's just stop in here and get her a little something.*"

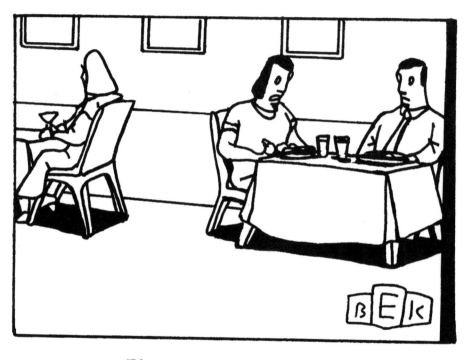

"I have a vague sense of dread and this
has a wonderful Mediterranean flavor."

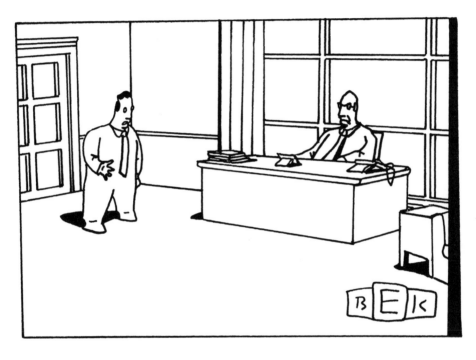

*"I thought you said I should take the ball
and slowly meander around with it."*

"It's nice to finally be able to put a face to a humiliating nickname."

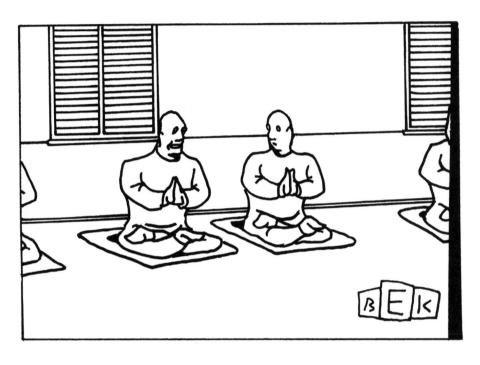

"*I pick up most of my wisdom from celebrity interviews.*"

"What time will you come back to bite me in the ass?"

"No biggie."

"Will I still be able to insanely distort reality
to the horror and upset of everyone around me?"

"I can't remember if I didn't like his second book or his second wife."

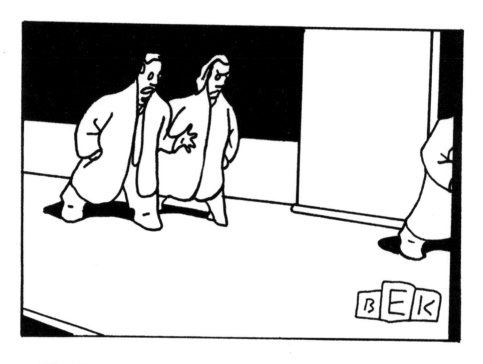

"There has to be room in the relationship for me to say I'm divorcing you."

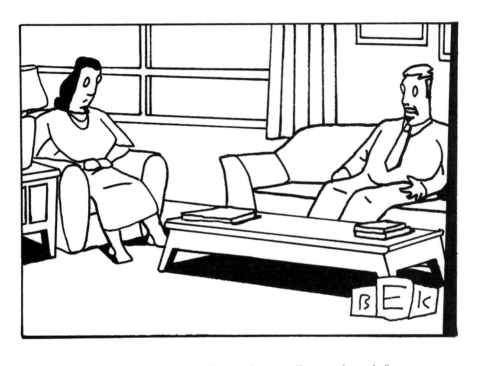

"Let's go somewhere fun and not really experience it."

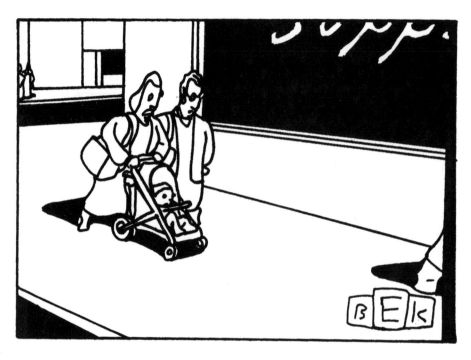

"Being a mother who fetishizes every aspect of parenting is a full-time job."

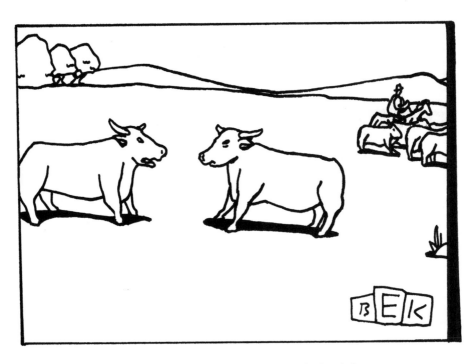

"I disagree with a lot of the way he herds."

"I don't have a lot of edge—I just hate you."

"I am looking for a position where I can slowly lose sight of what I originally set out to do with my life, with benefits."

"I'm looking for something slightly more perfect."

"Now there's all this mythology about how I'm crabby."

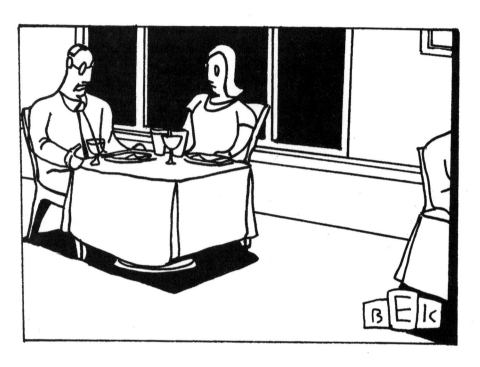

"You're much more than just a medicated face."

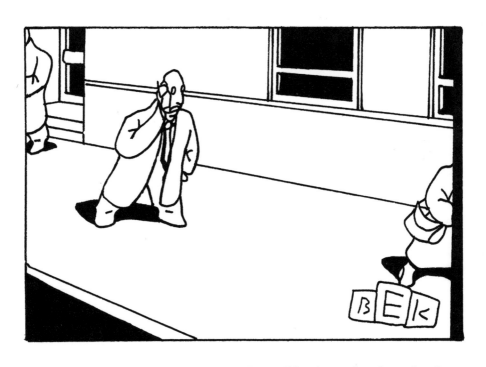

"I have this fantasy of everyone else in my life reinventing themselves."

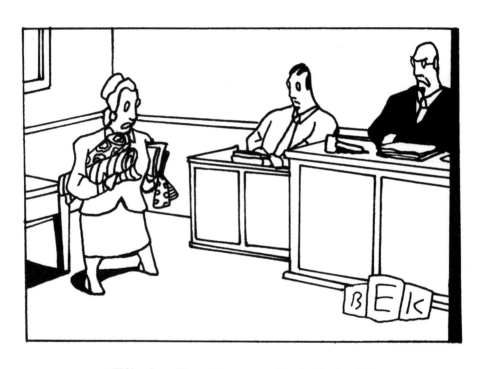

"If it please Your Honor, may I redo the bench?"

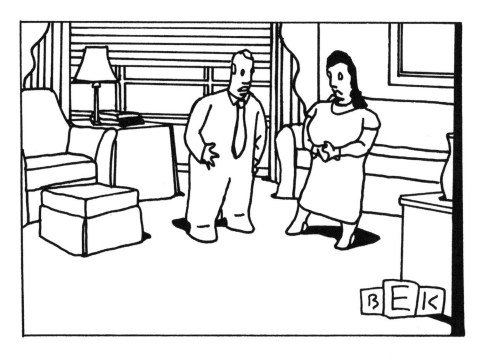

"I went to the farmers' markets with my first wife. I don't
know if I want to go through all that again."

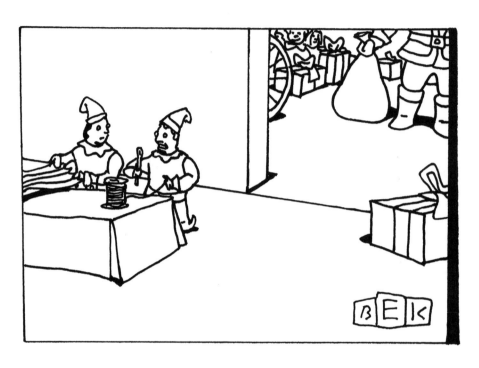

"Obviously, behind all the jolliness there's a lot of rage."

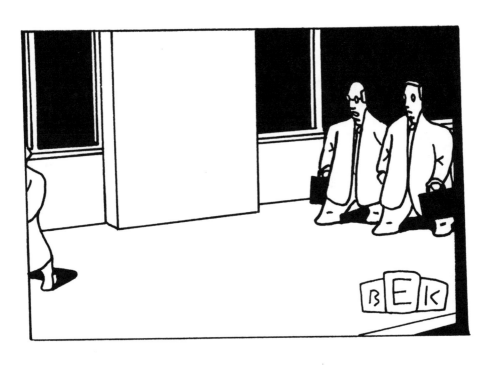

"Weekends I like to be able to panic without having all the distractions."

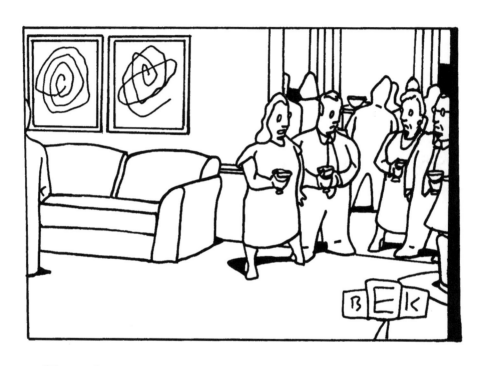

"Honey, show them how you slowly but inexorably grow apart from me."

"I'm tired of being chained to myself twenty-four hours a day."

"Mommy and Daddy and their friends are pretending they don't have horrible lives now."

"*Excuse me—I think there's something wrong with this in a tiny way that no one other than me would ever be able to pinpoint.*"

"Right now, I'm dealing with all this spring bullshit."

"But I hate su casa."

"Here you are—I've been all over the Internet looking for you."

"Would you describe the pain everyone else causes you as dull and throbbing or sharp like a knife?"

"It's so easy to become a person who only cares about candles."

"Truthfully, I like them better before they're hatched."

"She may have thousands of Buddhas everywhere,
but she's still a horrible bitch."

"Maybe this isn't the right heartless monolithic corporation for you."

"But then, because I got this horrible cut on
my finger, all these amazing things started happening for me."

"I liked him a lot better before I knew him."

"What about me? Am I not a natural disaster?"

"Would our big, tacky objects look good here?"

"What happened to that tiny little ounce of passion we used to have?"

"Why don't the lower classes ever get to be savagely indicted?"

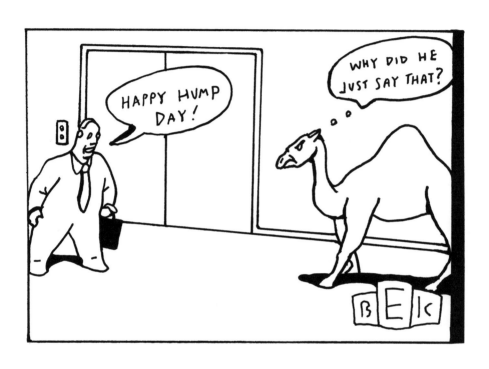

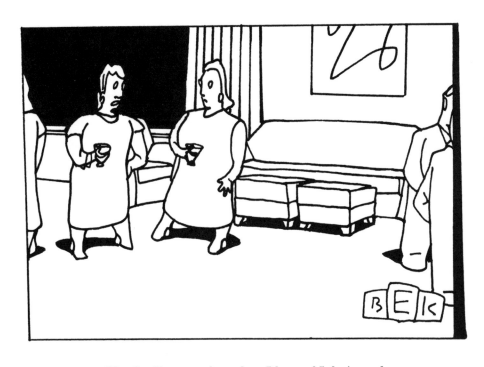

"I'm finally at a point where I learned I don't need
to please my nutritionist and my trainer."

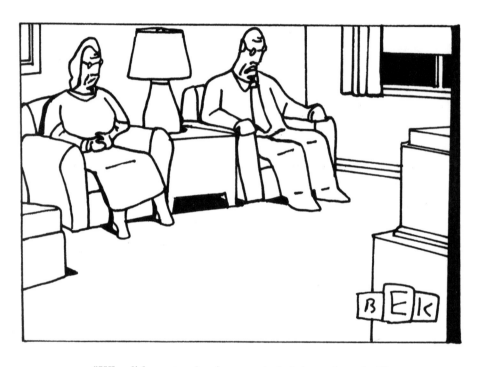

"Why did we stop having people fade into obscurity?"

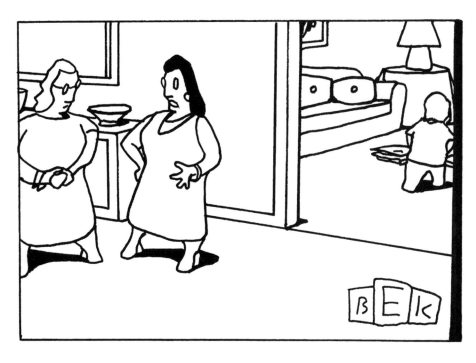

"I told him to come back when he's truly gifted."

"According to the preliminary tests, it's just the gypsy in your soul."

"This has been a really challenging time for me superficially."

"I married you. I didn't marry your vivid dreams."

"I want something stupid that I can think of as light."

"Let's focus on the matter that's way in the future, that's probably not going to happen, that's totally scary."

"You're not a fat cow."

"He's fine as long as I take my medication."

"I made a decision to be regretful and I've always looked back."

"Sometimes I worry I'm a wolf dressed as me."

"I don't know if I can take another lovely evening."

"Sometimes it's good just to have someone you can bounce heavy objects off."

"Is he commentating yet?"

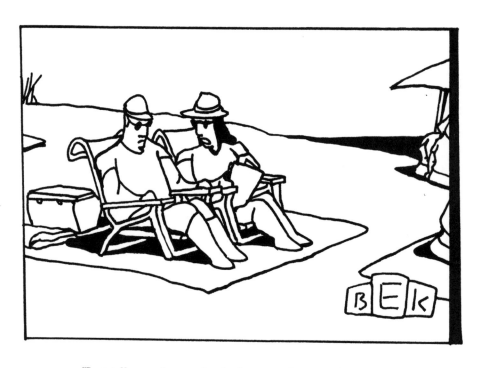

"Just tell me when you've had too much sun and you'd like to get back to our intense sexual psychodrama."

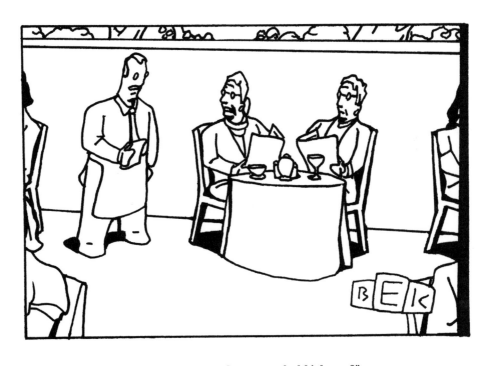

"Would you say the tuna salad kicks ass?"

"I can't believe he's dead—I just pretended I didn't see him the other day."

"Let's just stay in and contribute to the disappointing weekend box-office."

"It's a cookout—act stupid!"

"Have I been a terrible acquaintance?"

"I'll check with Ann—she takes care of everything involving human contact."

"You scampered away emotionally years ago."

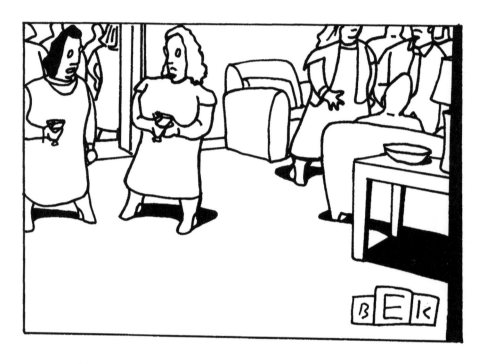

"Where are you desperately bidding for attention these days?"

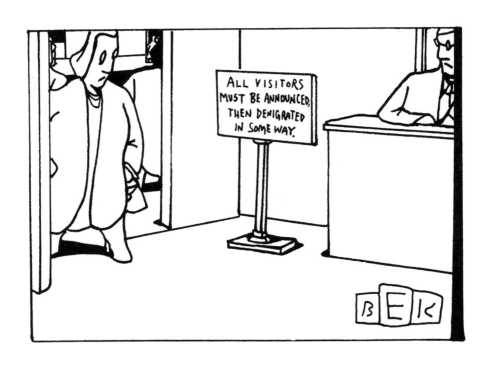

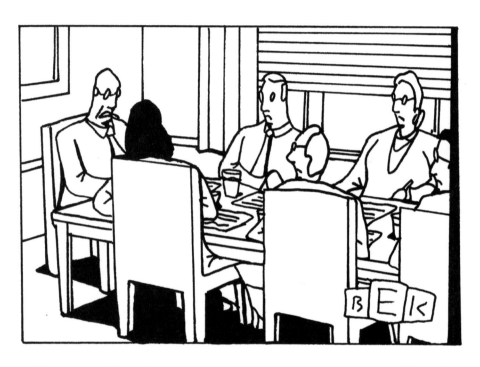

"*It's time to call in other people who don't know more but are just different.*"

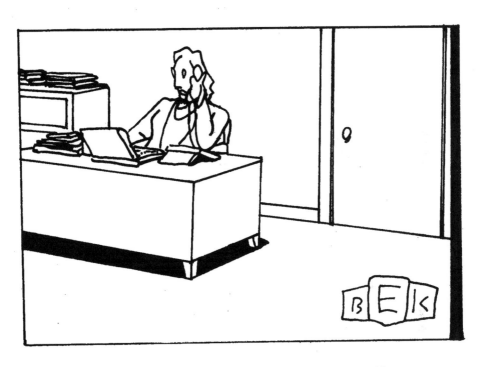

"He's becoming a monster—can he get back to you?"

"I bumped into a new girlfriend last night."

"I *am* big. It's the questions that got smaller."

"*I honestly believe one person devoting all their time
and energy to their appearance can make a difference.*"

"I'm sorry—I'm totally blanking on your species."

"It's nice just to be back in my sad, empty life."

"And this is our child, but we never use him."

"He wouldn't let me in, he wouldn't let me stay, he wouldn't let me out."

"*I would have gotten that report to you sooner, but
I wasn't held enough as a child.*"

"I've always had this vague curiosity about me."

"We thought a soulless, desolate community would be good for the kids."

"I suppose if I'm really honest with myself I'm not
totally fine with being slaughtered."

"He's not in recovery—he just speaks that way."

"I'm frustrated because I wish I were criticizing greater things."

"Is it casual casual or expensive casual?"

"My child's school is having an auction, so can your entire life come to a halt?"

"Really, only you can tell yourself to giddyup."

"Would you be a doll and go be angry at the world with Henry?"

"I'll take care of it impersonally."

"I have no idea where we parked the car, or why we exist."

"Don't take that tone of thought with me."

"I'm going to run away and join the national media circus."

"It's not a word I can put into feelings."

"Is he the really hot Montague?"

"I'm not trying to say anything—I'm just talking."

"Culturally, I'm a cat."

"Did you remember to kill the Petersens?"

"I like to keep up with all the latest things I don't care about."

"Can you come over here for a second and give this a pained look?"

"Making a difference doesn't make a difference."

"Then you give me no choice but to start journaling."

"It was years ago, for a nature documentary, and
they said it was going to be very artistic."

"We're going out with Joe and Rita next Tuesday. They want to know whether we want to talk about Tuscany or carbs."

"He's in the other room, grumbling about the culture."

"We're moving you from payroll to fear and paranoia."

"I'll wait and see the bloated, unfunny remake."

"What should we attach shame to today?"

"I've been with a lot of gentle woodland creatures
who turned out to be real sickies."

"We structured the deal so it won't make any sense to you."

"*Should we talk about what's wrong with everyone we know or what's wrong with everything we do?*"

"I woke up in a strange marriage with my clothing off."

"Are you open, emotionally?"

"Oh, I meant 'when are we going to get off this merry-go-round' in a larger sense."

"You symbolize everything that's wrong with me."

*"He wrote that brilliant book about that big social
trend that never actually happened."*

"When we first started seeing each other, we would always use the same word for snow."

"I have half an hour if you want someone to get sucked into your drama."

"If we're all just energy, then why don't I have any?"

"I'd love to, but I have a million lonely ritualistic things I need to do."

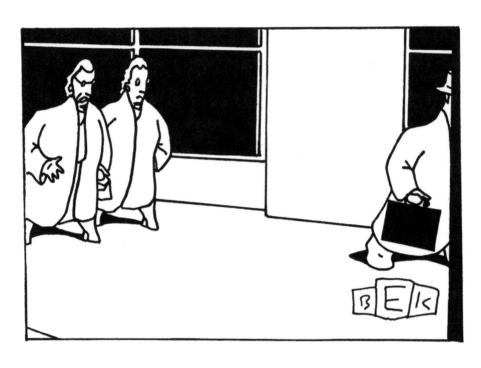

"At this point, I'm just complaining on fumes."

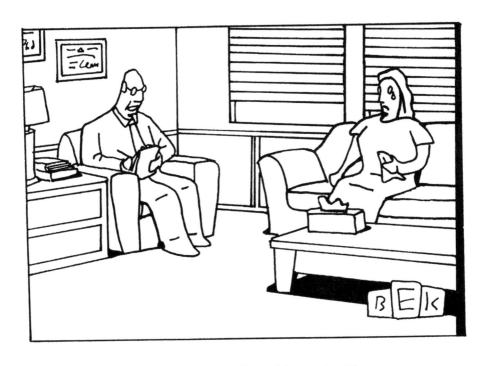

"Hey, I'm just messing with your head."

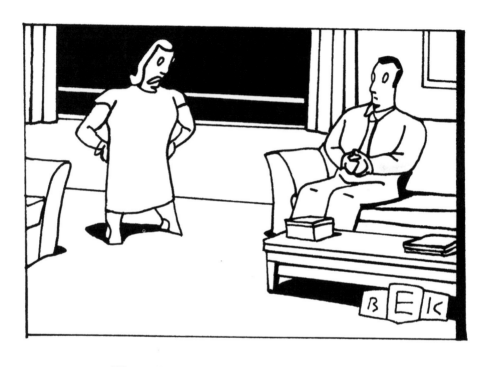

"Yes, you'll do it? Or yes, you wish I were dead?"

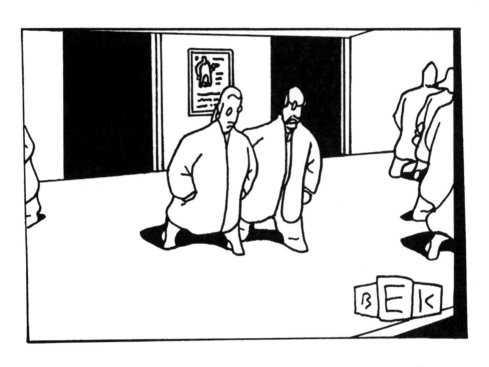

"I thought the vaguely homoerotic undertones would be better."

"There'll be other horrible men who don't really like you."

"You can hide, but you can't run."

"We're going to be late for the awkwardly standing around."

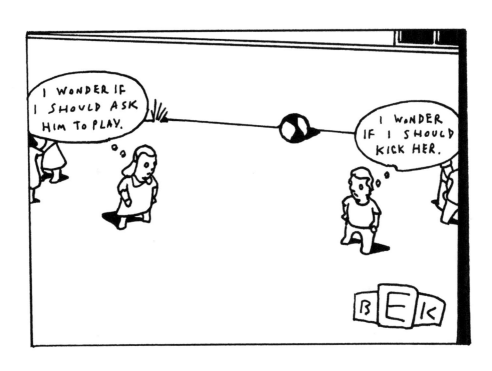

"*I have a bad association with people.*"

"Where does he get all his ideas?"

"*Tell me—I could use a good wry snort of derision.*"

"Everyone needs nice things to get sick of."

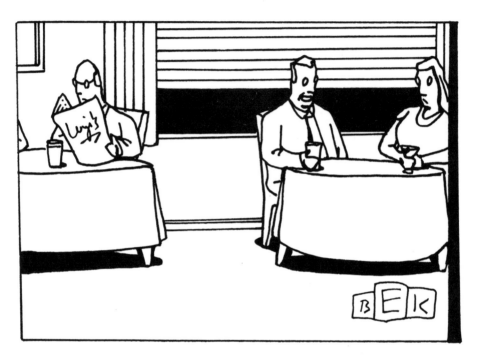

"Don't get me wrong—I'm pro crazy bitches."

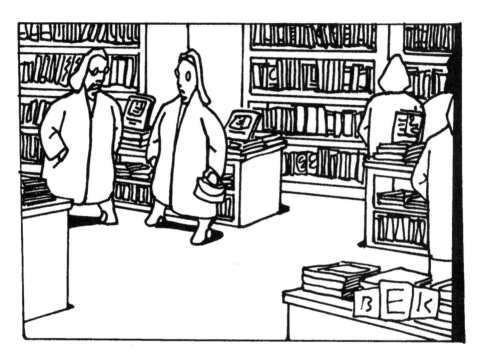

"He's one of those amusing writers I know I would hate."

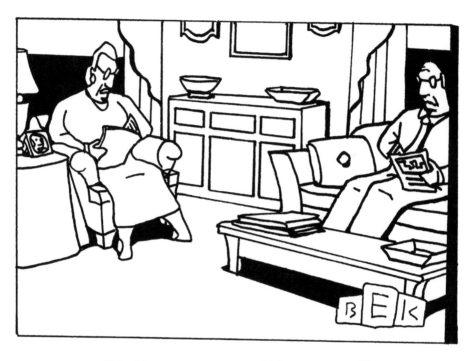

"Would you care to put your filthy paws on me?"

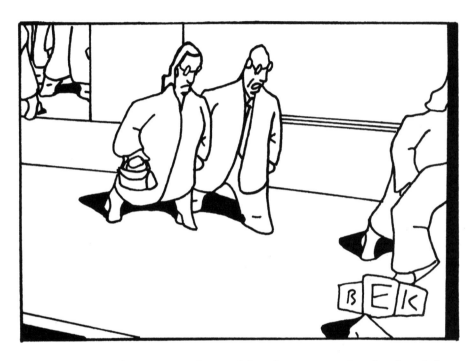

"Seeing it again, I was newly struck by whatever you thought about it."

"At least if we die, we'll be together albeit in completely different psychic spaces."

"Oh, I'm sorry—this is George, the first person at this
party I thought I was going to go home with."

"I want us to go over all the psychological intricacies
of everything in the world and then we can move on."

"I find the yoga helps me to be more irritating."

"Tonight I'll be performing a monologue about where I like to shop, my hair color, and something my mother did that upset me."

"Why do we need some piece of paper to say that we hate each other?"

"I just have to create a few loose ends for other people
to clear up, and then I can get out of here."

"It looked cute when I saw it on someone pretty."

"You're both miserable wretches, but I suppose that's beside the point."

"*I thought the horrible reception was very tastefully done.*"

"I carry all my stress in Margaret's back."

"Sometimes it seems like you don't want to talk about baby strollers."

"Apparently, they're going through a very bitter courtship."

"Come on in—just throw your coats in the garbage."

"What about here? This looks like a good spot for an argument."

"You have a mild form of harshness."

"We just want you to have something to fall back on, in case being famous for nothing in particular doesn't work out."

"She already had someone taking care of dessert.
We're bringing forced gaiety."

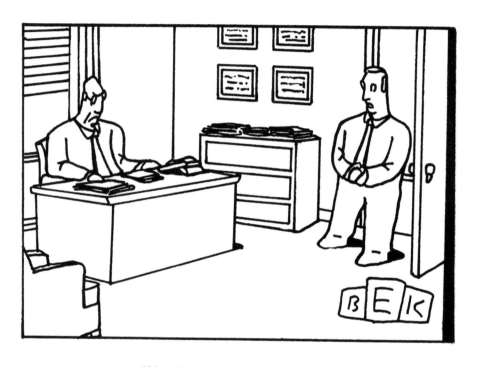

"Should I rationalize or backpedal?"

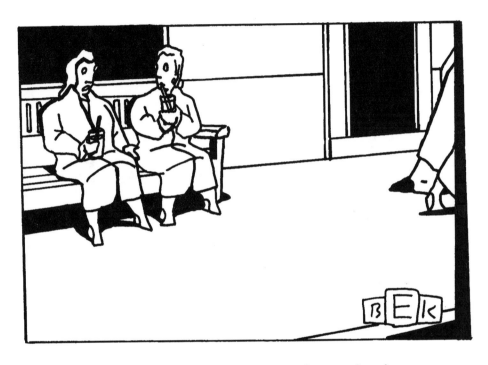

"Do you know how many calories you burn up dragging yourself from place to place wishing you were dead?"

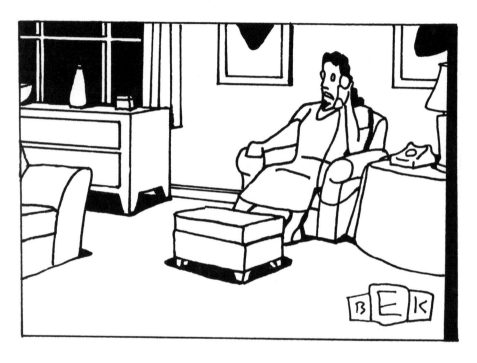

"I'm trying to look at it from my point of view."

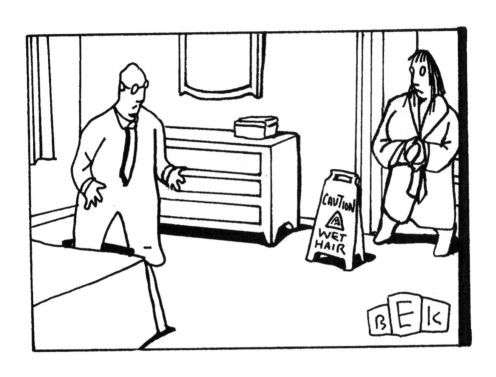

"I saw the most fascinating picture of a celebrity getting a cup of coffee today."

"I just think men find female homicidal maniacs very threatening."

"I suppose owning everything in the world gives them a certain cachet."

"I don't want to go out with the Hartmans—we're too depressing."

"Your Honor, my client feels like you're judging him."

"He was gingerbread and he ran away—it's time to move on."

"How slowly should I do this to make you the most upset?"

*"If you don't like it you can always use it as another example
of how I have no idea who you really are."*

"I just have a few minor fixes that will ruin everything you've come up with."

"It will be nice to get out, have a few bitter generalizations, and come home."

"We're going to beat this thing apart."

"I hate it when we make up."

"This fish has forced me to confront all the things
I did wrong with my last fish."

"I just want to go home, crawl into bed, and do some more work."

"I'm a vegetarian who eats meat."

"How do you juggle your career and your depression?"

"Tommy, you sang along very nicely, but you didn't knock it out of the park."

"I can't believe you symbolize peace when you're such a bitch."

"He died alone with his family."